T0115677

THE
WILLOWDALE HANDCAR

OR

THE RETURN OF THE BLACK DOLL

BY

EDWARD GOREY

Afterwards a gold ring embellished with leaves, grapes, etc. was found; inside were engraved IRON HILLS and the letters D.M.G., which last stood for the words 'Don't move, Gertrude'.

Harcourt, Inc.

Orlando Austin New York San Diego Toronto London

Copyright © 1962 by Edward Gorey

All rights reserved. No part of this publication may be reproduced or
transmitted in any form or by any means, electronic or mechanical,
including photocopy, recording, or any information storage and retrieval
system, without permission in writing from the publisher.

For information about permission to reproduce selections from this book,
write to trade.permissions@hmhco.com or to Permissions,
Houghton Mifflin Harcourt Publishing Company,
3 Park Avenue, 19th Floor, New York, New York 10016.

www.hmhco.com

First published in 1962 by the Bobbs-Merrill Company

Reissued with the permission of The Gorey Estate

Library of Congress Cataloging-in-Publication Data
available upon request
ISBN 0-15-101035-8

Printed in China

First Harcourt edition

SCP 11 10 9 8 7
4500824197

For Lillian Gish

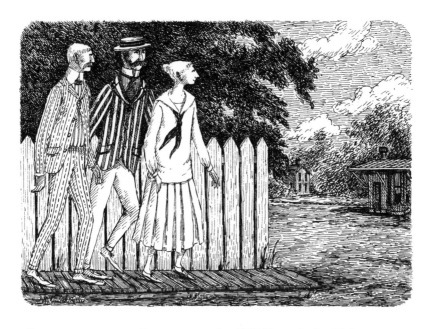

One summer afternoon in Willowdale Edna,
Harry, and Sam wandered down to the railroad
station to see if anything was doing.

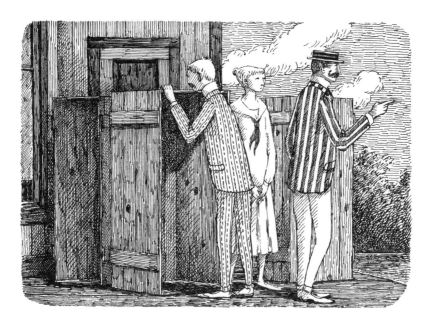

There was nothing on the platform but some empty crates. 'Look!' said Harry, pointing to a handcar on the siding. 'Let's take it and go for a ride.'

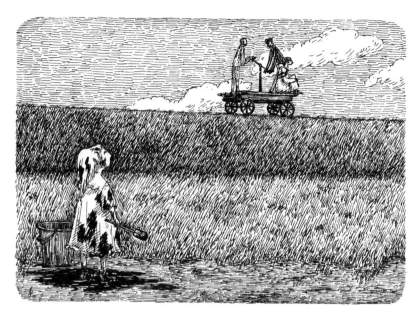

Soon they were flying along the tracks at a great rate. Little Grace Sprocket, playing in a home-made mud puddle, watched them go by with longing.

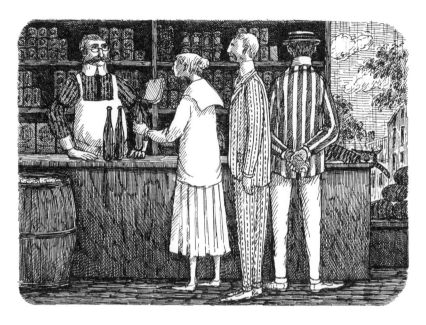

At Bogus Corners, the next town down the line,
they stopped to buy soda pop and gingersnaps
at Mr Queevil's store. 'How are things over
in Willowdale?' he asked. 'Dull' they said.

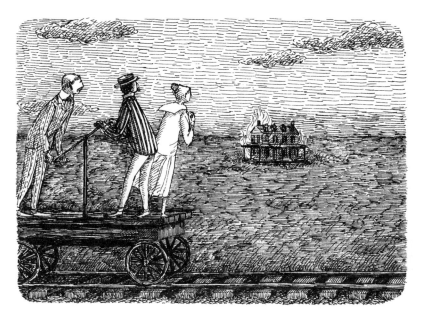

A few minutes after they were on their way again,
they saw a house burning down in a field.
'Whooee!' said Sam. 'The engines will never
be in time to save it.'

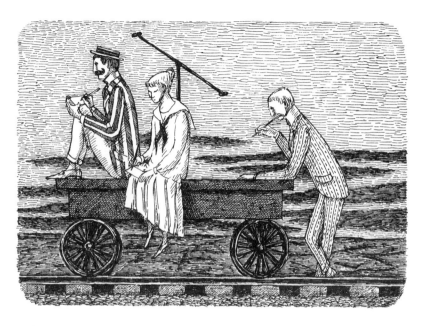

The next morning they wrote postcards to every-
body, telling them what they were doing and
didn't know exactly when they would be back.

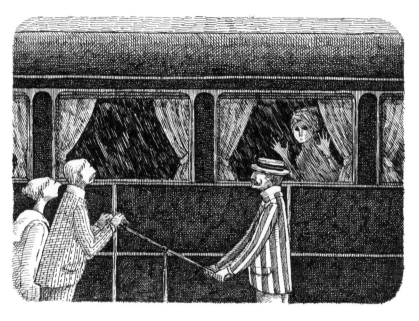

At 10:17 the Turnip Valley Express rushed past.
A frantic face was pressed against a window
of the parlor car.

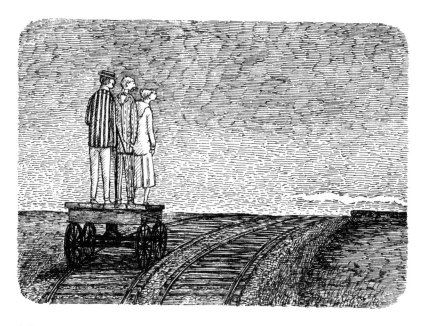

'Gracious!' said Edna. 'I believe that was Nellie
Flim. We were chums at Miss Underfoot's Seminary.
I wonder what can have been the matter.'

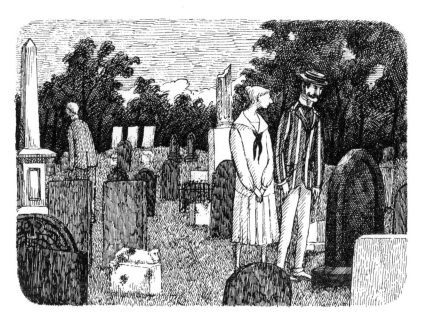

*In Chutney Falls they hunted up the cemetery
and peered at the tombstones of Harry's mother's
family.*

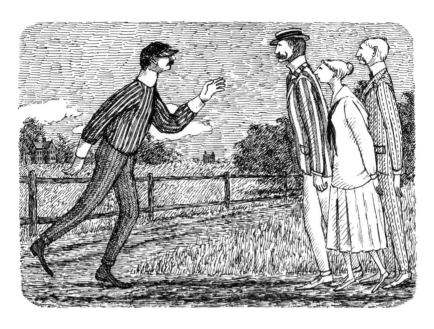

Later they ran into Nellie's beau, Dick Hammerclaw, the local telegraph operator. He asked if they'd seen her. He seemed upset.

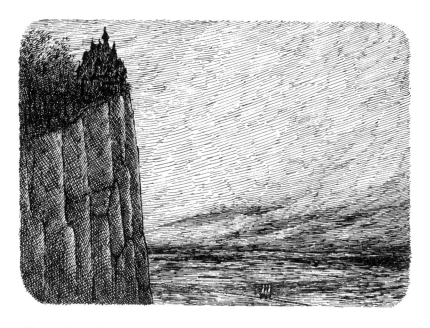

Near Gristleburg they saw a palatial mansion on a bluff. 'That's O Altitudo,' said Sam 'the home of Titus W. Blotter, the financier. I saw a picture in a magazine.'

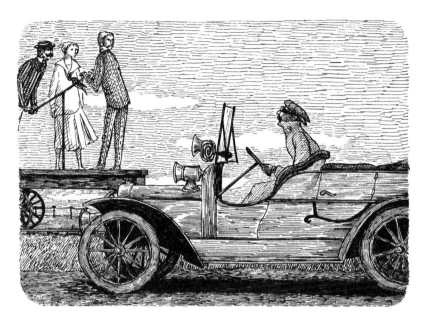

Several days later a touring car drew up alongside
them. The driver called out something unintelligible
concerning Dick before he shot away out of sight.

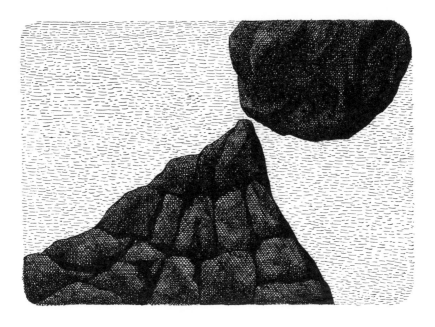

An undated fragment of the 'Willowdale Triangle'
they found caught in a tie informed them that
Wobbling Rock had finally fallen on a family
having a picnic.

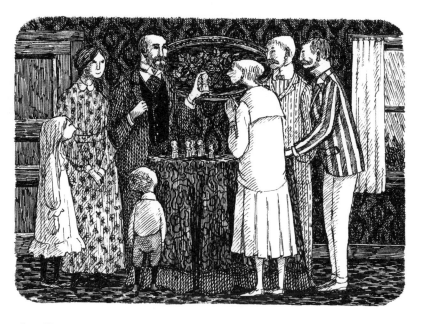

In Dogear Junction they paid a call on Edna's
cousins, the Zeph Claggs. He showed them a few
of the prizes from his collection of over 7,000 glass
telephone-pole insulators.

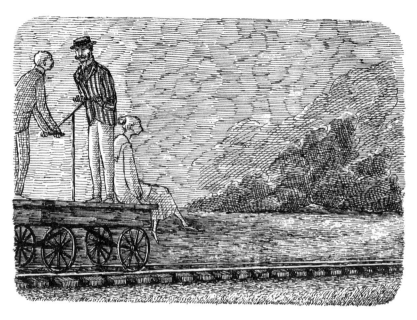

The following week Mount Smith came into
view in the distance; dark clouds were piling
up behind it.

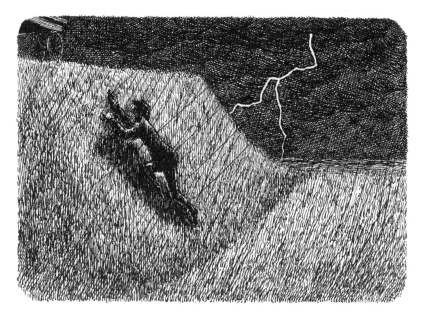

During the thunderstorm that ensued, a flash
of lightning revealed a figure creeping up
the embankment.

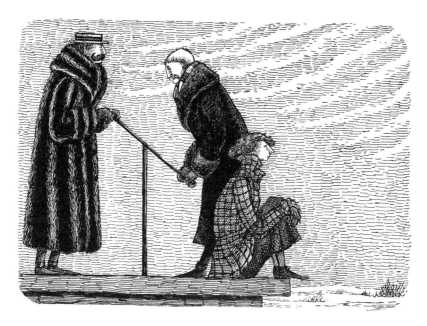

Some months went by, and still they had not returned to Willowdale.

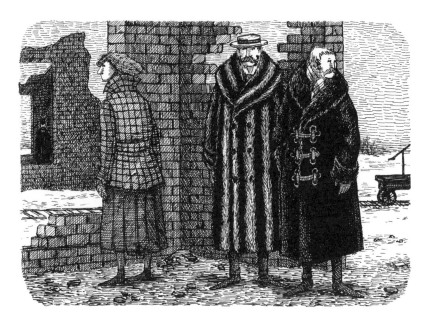

They visited the ruins of the Crampton vinegar works, which had been destroyed by a mysterious explosion the preceding fall.

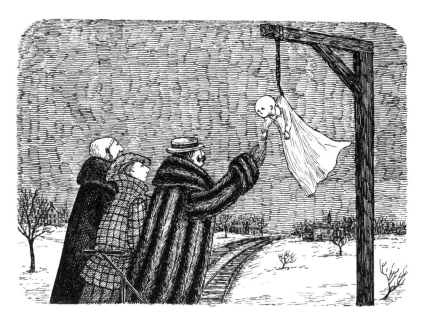

At Wunksieville they rescued an infant who was
hanging from a hook intended for mailbags.

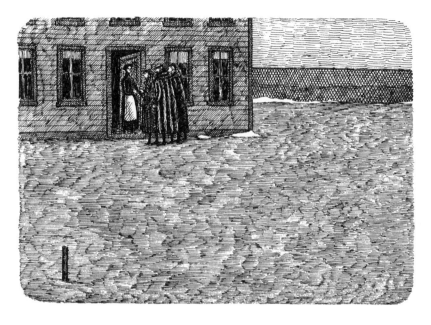

'How much she resembles Nellie!' said Edna. They
turned her over to the matron of the orphanage
in Stovepipe City.

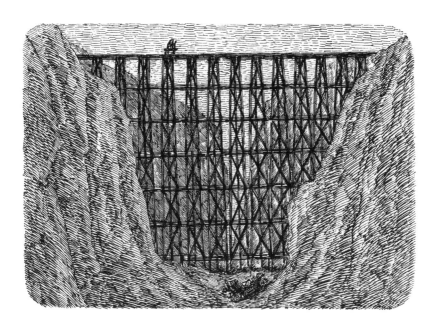

From the trestle over Peevish Gorge they spied the wreck of a touring car at the bottom. 'I don't see Dick's friend anywhere' said Harry.

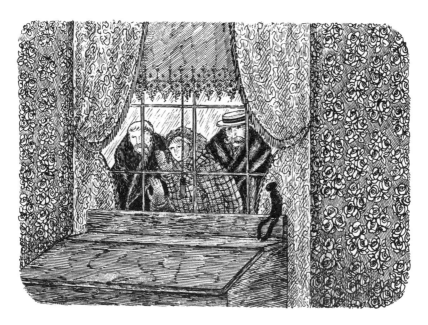

In Violet Springs they learned that Mrs Regera Dowdy was not receiving visitors, but through a window they were able to see the desk on which she wrote her poems.

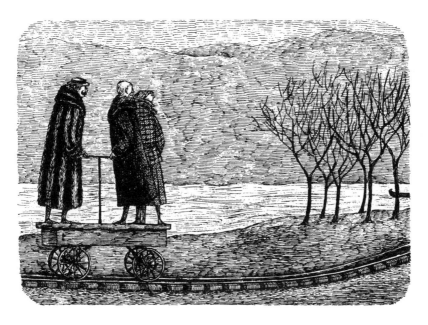

As they were going along the edge of the Sogmush River, they passed a man in a canoe. 'If I'm not mistaken,' said Edna 'he was lurking inside the vinegar works'.

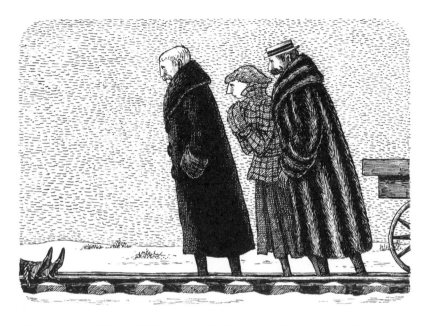

Between West Elbow and Penetralia they almost
ran over someone who was tied to the track.
It proved to be Nellie.

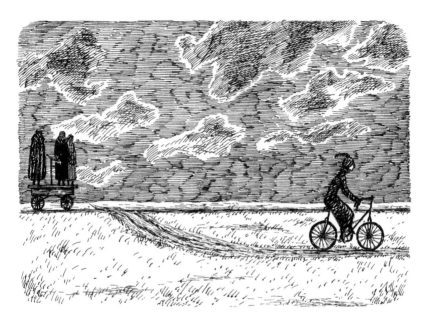

*Despite their entreaties, she insisted on being
left at the first grade crossing, where she got
on a bicycle and rode away.*

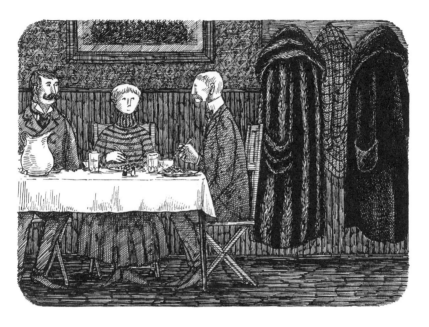

That evening they attended a baked-bean supper
at the Halfbath Methodist Church. 'They're
all right,' said Sam 'but they're not a patch
on Mrs Umlaut's back home'.

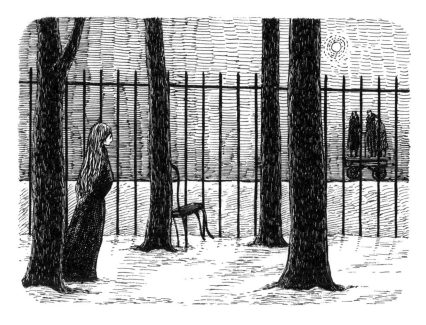

A week later they noticed someone who might be Nellie walking in the grounds of the Weedhaven Laughing Academy.

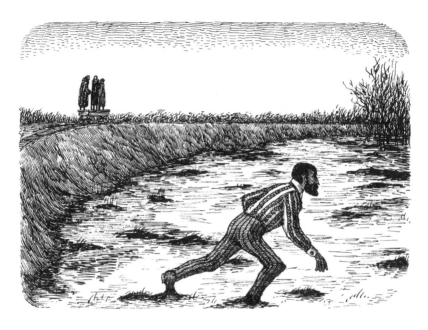

On Sunday afternoon they saw Titus W. Blotter
in his shirtsleeves plunge into the Great
Trackless Swamp.

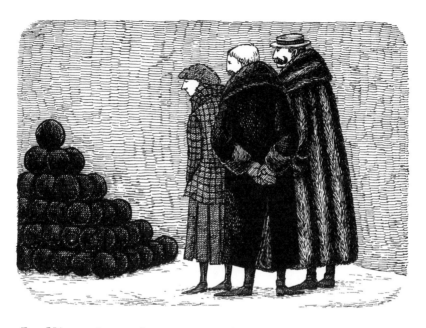

In Hiccupboro they counted the cannon balls in the pyramids on the courthouse lawn.

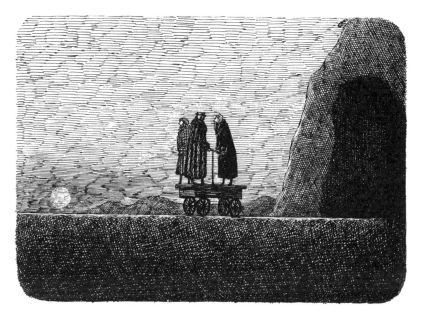

At sunset they entered a tunnel in the Iron Hills
and did not come out the other end.